THE PRIDE OF EWE KENTE

THE PRIDE OF EWE KENTE

Ahiagble Bob Dennis

SUB-SAHARAN PUBLISHERS

First published in 2004 by
SUB-SAHARAN PUBLISHERS
P.O. Box 358, LEGON, ACCRA
E-mail sub-saharan@ighmail.com

© Text Ahiagble Bob Dennis 2004

ISBN 9988-550-27-8 (SOFT COVER EDITION)
ISBN 9988-550-71-5 (HARD COVER EDITION)

All rights reserved. No part of this publication may be produced, stored in a retrieval system or transmitted in any form or by any means electronic, mechanical, photocopying, recording or otherwise, without the prior written permission of the publisher.

Layout, Cover design and Illustrations by
Kwabena Agyepong

Photographs:
The photographs on pages 35, 56 (top), 57 (bottom) and 58 are by Virginie Vlaminck; those on top of pages 29, 31 and 32 are by Kristine Kier, a Danish documentary photographer; those on pages 7 (right), 59 (top) and 70 are by Christopher Payne. All the others are by Inge Bonde Christensen.

Contents

Author's Preface	7
The History of Kente Weaving	9
The origin of Ewe kente	11
The name "kente"	12
Ewe land and people	14
The big migrations	14
The loom and associated taboos	17
The life of kente weavers today	19
The Art of Kente Weaving	25
The tools	26
Setting up the equipment	29
Weaving	32
Weaving yarns	33
Master training	37
The Unique Features of Ewe Kente	39
Quality	40
Uses of kente cloth	42
Festivals	45
Meanings of Ewe Kente	49
Afterword: Keeping Kente Weaving Alive	71
Further Reading	72

6

Author's Preface

My wish is to highlight the beauty of Ewe kente and to help popularise it.

Among the Ewes, the art of weaving is a legacy handed down from father to son, and for me it was no exception. I learned the trade the informal way. I was inspired by the rotation of the skein winder and began assisting my father by winding threads onto bobbins at an early age. Although it was a long monotonous process, I enjoyed spinning the crank around and around. It takes skill and it is nice to look at. As is general practice for all trainees, I learned the names of all the colours and designs, and learned about the starching process alongside my practical work. I moved on to the loom as soon as my legs could reach the treadles. My first day of weaving was so tiring as the throws of the shuttle were slow and laborious. I continued, though, with increasing speed until, at eleven years old, I had all the skills and knowledge to become a master weaver.

One thing I find so fascinating about weaving is the alteration of the shed and the various wefts created. I learned that, just as in life, one thread is weak, while threads woven together are strong. With this experience in the weaving field it is my burning desire to share my knowledge with anybody ready to listen and learn.

On that note I wish to express my heartfelt gratitude and appreciation to Inge Bonde Christensen and her husband Steffen Rasmussen, the director of Ibis, a Danish non-governmental organisation. They stood beside me until this work was completed. I wish to thank Joanna Collins, who edited the text.

I am grateful to the Royal Danish Embassy and the British Council for providing funds for the project.

I am thankful to all my colleagues, the experienced master weavers, for their co-operation. Jimmy deserves special mention for his assistance. I also owe

thanks to Madam Martina Mamle Odonkor, a senior Associate of Frontier Analysis Ltd. for the assistance she provided me, for her encouragement and for linking me up with Mr. Emmanuel Gawuga. I thank him for his patience, detailed editorial analysis and suggestions regarding the work. I must also put on record the contributions made by the following: Madam Alexandra Wilson, formerly of the Department of Archaeology, University of Ghana; Madam Anne Weber Carlsen, Ibis Organisation Development Advisor; and Dale Massiasta, the Director of the Blakhud Museum of Ewe Culture at Agbozume.

I wish to record my gratitude to my mother and to all my brothers and sisters, especially Sarah, and to my father, Gilbert Bobo, a renowned weaver, for their constant support.

Any errors in the text are mine.

The author

The History of Kente Weaving

Ewe and Ashanti kente cloth

Kente is a Ghanaian textile traditionally closely linked with royalty, especially among the Ewe and Ashanti peoples. Although the development of the art of kente weaving cannot be attributed to these two ethnic groups alone, the evolution of this unique form of artistic expression has been identified with them to a large extent.

Kente is woven in strips about four inches (9.5 centimetres) wide which are then sewn together to form larger pieces of cloth for use by men and women. Both the Ewe and Ashanti weavers claim to have developed kente weaving. Although the Ewe produce their own kind of woven cloth and the Ashanti produce theirs, the two types of kente have much in common. Both groups use similar equipment and methods of weaving. Both use wooden looms and other tools. They weave similar sized narrow strips which are joined to form a large piece of cloth.

Kente cloth is distinguished

from other types of narrow band weaves in Ghana by the designs. Ewe and Ashanti kente carry intricate warp and weft designs that are distinguished by their names. The designs have traditional meanings and different uses in the communities. Characteristically, the Ashanti kente has geometric shapes woven in bright colours along the entire length of the narrow stripe. The Ewe kente often creates a tweed effect by plying together different coloured threads in many of the warps. Another very specific feature of the Ewe kente is the use of particular forms which represent human beings, animals and ordinary household objects such as combs, chairs and tables. Also present in Ewe kente are letters and even simple phrases and names of objects and people, which are carefully copied and incorporated into the design. Some of these are done by people who have never been to school and cannot read or write.

The dominant colours of Ewe kente can best be described as 'calm'. They are predominantly muted yellow, red, green, black, white and blue, woven in different designs and combinations, whereas the dominant colours in Ashanti kente are usually magenta, yellow, bright green, bright blue and red, colours that might simply be described as 'cheerful'.

THE ORIGIN OF EWE KENTE

Much knowledge has been lost about the origin of Ewe kente weaving. However, according to oral tradition the ancestors of the Ewe people carried their weaving tradition from Notsie in Togo or even from their earlier settlements.

Many weavers talk about kente as their heritage and about maintaining the weaving tradition which they have inherited from their forebears. The most dominant tradition about the origin of Ewe kente, remembered by Ewe weavers in the Volta region of Ghana, is that in its current form it dates back four or five generations. Kente weaving is a trade that is mostly passed down through families.

According to the weavers the origin of kente cloth can be traced to the *Spider-Web* myth, which describes the first weaving. When old men tell this story, they begin it in traditional fashion, with an Ewe adage. This adage states that 'when a hunter returns from his hunting expedition and claims that he shot at an animal and missed, there is no doubt'. In other words, no hunter would lie about missing his target, no-one boasts about being unsuccessful. So it is with this story.

It was believed that a hunter called 'Se' observed a spider spinning its web when he was on a hunting expedition. The spider was much more skilful than he was and he felt humbled. He was so impressed by the intricacy of its art that he was determined to try and do the same. By imitating the natural art of the spider, using sisal and raffia to weave, he produced the first textile made by humans.

Historically, Ewe weavers have certainly been weaving and trading cloth beyond their borders for several centuries. Since the nineteenth century and perhaps earlier, they have supplied many different clients across the region with a wide variety of designs which reflect their flexibility and creativity. European missionaries in the nineteenth century mentioned how productive the Ewe weavers were.

In the course of history specific kente designs have been woven

for special social and religious occasions. Within Ewe culture kente has thus become a visual presentation of history, oral literature, philosophy, moral principles, religious beliefs and rules of social conduct. This can be seen during burial rites, for example, when everybody dresses in kente woven in black and red colours, whereas white colours are normally associated with out-dooring, a ritual that takes place soon after a baby is born, and, in some cases, victory.

THE NAME 'KENTE'

According to the Agotime people, an Ewe people living in the Volta Region, 'kente' was not originally the name of the cloth. The Ewe word for loom is *agba*, and the word for cloth is *avo*. Together these two words form *agbamevo*, the Ewe name for any cloth woven on a loom. This was the word originally used for kente.

According to oral tradition, the ancestors of the Agotime weavers were once held captive by the Ashanti, but they did not understand the Ashanti language. Yet they had to teach the Ashanti how to weave, so they adopted a sign language and the use of certain simple Ewe words such as 'kee' (which means to create the shed by pressing the treadle) and 'tee' (which refers to the use of the reed to compress the weft yarn tightly). 'Kee' and 'tee' were put together to form 'keetee' or kente.

Ewe area showing different tribes and trade routes

THE EWE LAND AND PEOPLE

Culturally, the Ewe people belong to an ethnic group who are classified linguistically among the Kwa-speaking groups of West Africa. They occupy the land from the eastern bank of the Volta River in Ghana across to the western bank of the Mono River in the Republic of Togo. The Atlantic Ocean forms the southern frontier of the Ewe country and the northern frontier is the mountainous area around Hohoe in Ghana and Atakpame in Togo.

The whole area inhabited by the Ewe people – 190 kilometres from East to West, from Kpong in Ghana to Grand Popo in Benin and 160 kilometres from North to South, from Atakpame in Togo to Denu in Ghana – encompasses a number of ethnic sub-groups such as the Avetime, Nyagbo and Tafi groups in Ghana and the Adja and Mina groups in the Republic of Togo and Benin.

THE BIG MIGRATIONS

According to an Ewe legend, they originated from the town of Ketu in Benin. The population of the neighbouring Yoruba people grew and compelled the Ewes and other tribes to move their settlements westwards.

The pattern of migration of the Ewes seems to have been a gradual movement of people into uninhabited lands. Most of the virgin lands through which they travelled grew into temporary settlements. Here they developed from hunting to farming and harvesting, and then they reared their families before continuing their march.

Wherever they went, their leaders took with them their traditional stools. Rituals are performed over the stool and the power of the chief then resides in the stool. The chief sits on the stool during ceremonial occasions. Without the stool, a chief is powerless. These stools are still much respected in parts of Ghana and used in traditional ceremonies.

Towns in Volta Region

Two major convoys were formed during the migrations. One of these subgroups settled near the Mono River and called it Tado. The second group founded their settlement between the rivers of Haho and Mono. This settlement later became the Notsie kingdom. The settlement at Notsie developed into a great walled city like Ketu.

After a long period of separate development, the various fragmented groups came to the realization that in unity lay strength against common foes, and so they stopped undermining each other with petty quarrels and jealousies, and laid a firm foundation for a mighty Ewe kingdom, with Notsie as the seat of the administration. The whole community lived within the walls with separate heads or chiefs but collectively ruled by a supreme king.

The earlier kings of Notsie ruled wisely and the kingdom progressed and expanded in all directions. Unfortunately, a tyrant, whose despotic rule led to the disintegration of the kingdom, succeeded the first rulers. That tyrant was Agorkoli. The various groups of Ewes at Notsie were collectively persecuted and denied justice at the court of King Agorkoli. All opposition to his misrule was instantly crushed by ruthless executions.

In dread of Agorkoli's burning anger, mistrust and hate of his own people, the citizens promised loyalty to perform any task he might set them, since they were his subjects. However, when human beings are overstretched and denied basic rights and justice, fair play and dignity, the limit of human endurance is reached and people may rise up and revolt against authority. This happened to the Ewes at Notsie when they could no longer bear the misrule of their king. A great number of Ewes and other migrant ethnic groups met secretly and their leaders took a solemn oath to flee from Notsie. On a certain night, the escape took place under the cover of vigorous drumming, dancing and hysterical singing, which continued throughout the night.

During this migration the Ewe people were divided again, into three main groups. One of the

groups went north and founded a number of towns in the area east of the Volta River, including the towns of Hohoe, Peki and Kpando. Another group founded the settlements of Ho and Takla. The third group, known as the Dogboawo, led by their chief, Torgbi Wenya, moved southwards until they met the Atlantic Ocean. Members of this group settled in the coastal zone and founded towns like Lome and Keta.

These are the groups of Ewe that carry on with the art of kente weaving in the present day.

THE LOOM AND ASSOCIATED TABOOS

In the past weavers only used fixed or in-situ looms placed in their own houses. Periodically these weavers, who mostly followed traditional religions, offered sacrifices of animals or fowls and drinks to the deities that inspired their creative work. The loom was hence deified and the spot became sacred. No part of the loom could be used to hit anybody because it was believed to be sacred. An old loom could on no account be burnt, used as firewood or broken up. Falling inside a loom implied falling in an area made sacred through sacrifice and deification.

In the past, women were excluded from sitting at a loom and weaving. The fact that sacrifices in fixed looms involved the blood of animals or birds throws light on this exclusion. It also helps explain why it was taboo for women during their menstrual periods to sit on the weaver's stool when he left his loom. When

a woman menstruates the flow of blood is comparable to the flow of blood from a sacrificial animal or bird. The menstrual blood was believed to pollute the sanctity of the loom. When this happened in spite of the taboo, a fowl had to be sacrificed to purify the loom. In many instances, the woman, during her menstrual period, was not even allowed to address her husband directly or cook for him when he worked.

Fixed looms limited the weaver to a particular spot and could only be moved around by the weaver or his relation. Urbanisation, economic factors and Christianity have collectively brought about a revolution in loom production and the gradual erosion of taboos and rites associated with looms and loom parts. The revolution saw the creation of the mobile loom, which can be located anywhere, even in a rented house, moved at will and placed in any convenient spot. Movement of the mobile loom does not encourage the offer of sacrifices and deification because the deity or 'muse' must identify itself with a fixed abode in order to respond to the needs of the weaver when called upon. Moreover, today most Ewe weavers profess Christianity and although they may be descended from a lineage of weavers who were adherents of traditional religion, they have either shed their old beliefs or are not prepared to talk about rites and taboos associated with the loom or weaving itself.

With the introduction of mobile looms, the gradual decline in the use of in-situ looms and the influence of Christianity, all religious practices and taboos associated with weaving or the loom have seen a steady decline. To most of the present generations of weavers these taboos are more or less just old dogmas that have little relevance or meaning to their practical work. They cannot therefore explain the reasons for things they do or beliefs about weaving.

Similarly, the influence of Christianity, urbanization and economic pressures have resulted in the gradual erosion of taboos that prohibit women from weaving. The number of female weavers in the region is gradually increasing as a result.

THE LIFE OF KENTE WEAVERS TODAY

Weavers are spread throughout the area from the south to the middle of the Volta Region of Ghana, as well as in parts of Togo. In Ghana, the population of weavers is denser north of the Anlo, Some and Keta areas, particularly in the Agotime traditional area. There is a loom or weaver in nearly every house in the towns and villages in the Agotime area and the Agbozume townships and surroundings. Most weavers (male and female alike) weave for a season, then engage in subsistence fishing or farming for a period and sell their cloth, either in the local markets like Agbozume or by going round to bigger towns, within the region or further afield, searching for buyers.

This situation has given rise to specialisation. Hitherto weavers had to construct their own looms and other equipment, and some weavers still do so. However, many now commission loom-makers who are specialised carpenters, and do not do any weaving themselves, to make them. Some of these carpenters also produce on commission or for direct sale other items such as skein winders, warp layers, bobbin winders and so on. There are other skilled workers who produce on a commercial basis such items as reeds or beaters, shuttles, bobbins, heddle pulleys and treadles and even heddles and sell them on market days to weavers. One major market for such items is Agbozume.

Today female weavers, liberated from most of the former restrictive taboos, are free to weave even during their menstrual periods without fear of offending any deity or muse. It is gratifying to note that nowadays only a negligible fraction of users of kente are worried about buying cloths woven by women. On the whole female weavers enjoy equal patronage with their male counterparts and the cloths the women weave sell for as much as those woven by men.

Women have always participated in the production of kente in other ways, when they were not menstruating. They spun raw cotton into yarn, dyed the yarn and

helped the men to sew the narrow strips of kente together by hand. Today both men and women usually do this using sewing machines. In addition, women promote kente as part of the Ewe cultural heritage, contributing to its sustainability. Besides this, women do most of the domestic work in the house and on the farm, cooking, child-rearing, fetching water and fuel, and carrying produce to market. This allows the male weavers to work full time, whereas the women do their weaving when they have fulfilled their domestic responsibilities.

The majority of the weavers in the Volta region prefer to market their own products. There are few middlemen in the kente business because of the low profit margins.

A few weavers weave on commission, and earn a good living. A small percentage of this category are employed by rich shopkeepers to weave for them and are paid agreed wages.

However, most of the present generation of weavers in the Volta Region do not earn much from their business and therefore experience economic hardship. They suffer from the lack of a ready market for their cloth, as well as the high cost of yarn. Some weavers sell their cloth in local markets such as Agbozume or larger towns, but most go further afield to search for buyers in major commercial centres. Kente merchandise is mainly sold to the tourist market, and is sometimes made to suit tourist tastes, but most towns in the Volta Region are not important tourist destinations, unlike Accra, Kumasi and Cape Coast. Within the Volta region there are therefore very few

Weaving equipment in Agbozume market

foreign tourists who might buy kente. It is for these reasons that most kente weavers engage in subsistent farming or fishing on a part time basis to make ends meet, even though all the weavers are working hard to preserve the art of Ewe kente.

A cross section of local buyers, users and traders in kente agree that the meanings of the names of the cloths do not influence their choices or the market potential of the cloth. The choice of cloth is influenced more by the colour and the occasion when it will be worn than by traditional names and meanings. Darker shades are associated with melancholy, grief and sorrow and are used mainly for mourning. Lighter shades are associated with happiness, victory and so on, although light colours are used for funerals of very elderly people who are said to have joined the ancestors, the 'home-call'.

Woman sewing kente strips

24

The Art of Kente Weaving

Kente weaving is a wonderfully complex process, which testifies to the highly skilled craftsmanship of our forbears.

The basic tools and weaving process are in many respects similar to those used in other forms of handloom weaving in West Africa and elsewhere. However, the differences in materials and technique give Ewe kente its unique qualities, described in the next section, The Unique Features of Ewe Kente.

Demonstrating the art of kente weaving

THE TOOLS

Uses of weaving tools

Weaving Tools	Ewe names of the tools	Functions
1. Loom	agbatsi	the basic tool: the frame which suspends the warp and other tools
2. Heddle	eno	pulls down alternate warp threads to create the shed (space) for the shuttle
3. Pulley	xevi	holds the heddles in an upright position
4. Bobbin	vumedi/ayitsi	large: used to carry the yarn for laying the warp small: used to carry the yarn for the weft, placed inside the shuttle
5. Bobbin Winder	emor	used for spinning
6. Shuttle	evu	carries the weft through the shed
7. Beater	eha	pushes, or compresses, the weft together during weaving
8. Breast beam	kabetsi	as the cloth is woven, it is wound onto the breast beam
9. Sword stick	vufo	used to keep warps apart when inserting more complex patterns
10. Treadles	aforke	pressed down to lower the heddles
11. Skein winder	ata	holds the yarn as the yarn is wound onto the bobbins
12. Sled (drag stone)	kpetesi	helps to keep the warp taut
13. Bobbin carrier	avortsiga	carries the large bobbins during warp laying

1

2

3

4

6

7

8

9

12

11

13

27

Kente weaving has its own handmade tools. These are made by the weavers themselves or by specialists in making weaving equipment who are not weavers themselves (See The life of kente weavers today, p19). The weaving tools, including the loom, are mostly constructed from wood and bamboo. For example, the bobbins are simple bamboo sticks with holes drilled in them.

Fixed looms are usually constructed by weavers while mobile looms are usually constructed by carpenters, sometimes, with guidance from the weaver. The most difficult part of constructing the loom is aligning the notches on the two upper beams.

One of the most important parts of the loom is the beater or reed. The size of the beater determines the width of the cloth, with narrower beaters being more traditional. The beater is rectangular in shape, built of two fine strips of bamboo with holes cut at each end, joined by reeds. It is suspended by two strings from a beam across the top of the loom.

The heddle is also rectangular, consisting of two strong sticks joined by fine strings. To construct the heddle, the two sticks are held apart with bent pieces of wood and the whole is put into a frame of very flexible wood, the heddle-making frame. Then the threads are wound between the two separated sticks in such a way as to make a loop in the middle of the threads. The warps will pass through these loops.

SETTING UP THE EQUIPMENT

Winding yarn onto large bobbins

Warp-laying

Stringing the heddle after warp-laying

Stringing the beater

29

Warp laying is the first step in setting up the equipment for weaving. The warp threads are those which extend right through the cloth, from one end to the other. First, the yarn to be used for the warp is wound onto large bobbins and these are put on the tines of the bobbin carrier.

Then two or more rows of pegs are set in the ground, approximately 62 feet (20 metres) apart, depending on the length of the cloth. At the end of this sequence there are two pegs close together. The person laying the warp unwinds a thread from each bobbin on the bobbin carrier, for example, twelve threads. He then winds the threads round the pegs to keep them straight and taut. At the final two pegs the threads must be securely crossed and tied, in the sequence of colours which has been decided upon, so as to maintain the correct sequence, a process calling for careful observation. A loop is formed called the 'nose' of the warp. As the person lays the warp, he uses stones to remind him of how many times he has taken the yarn from the bobbins to the 'nose'. The loops of the threads which form the 'nose' are cut so that each thread is divided into two threads, which will then be threaded through the heddle and beater. The Ewe call the warp-laying *avotsitsi*.

When the warp is ready for weaving it consists of 240 threads or more. The combination of the threads – either of a single colour or several colours – determines the character and the patterns of the finished cloth. The importance of the warp is illustrated by the fact that different types of Ewe kente cloth do not derive their names from their motifs but from the type of warp used.

When warp laying is complete, the heddles are strung, with the help of the heddle-making frame. In this process, the warp threads are passed through the loops in the heddle. In the main heddles, one thread is passed through each loop and in the pattern heddles, up to four threads are passed through each loop. The beater is strung next, with the warp threads passing through the spaces between the reeds.

The heddles and the beater, strung with the warp, are then

Warp tied to the sled

suspended from the beams placed across the top of the loom. The heddles are suspended from metal or carved wooden pulleys. Then treadles are attached to the lower strings coming from the heddles.

The warp threads are attached to the sled, which is weighed down with a stone. Spare warp is wound in a bundle on top of the stone. The other ends of the threads are tied together and attached to the breast beam to keep the warp taut during weaving.

For the weft, that is, the threads going across the cloth from side to side, smaller bobbins are wound with threads of different colours and types, depending on the cloth to be produced. The bobbins are then placed in shuttles ready for weaving.

WEAVING

The weaver sits upright on a stool with the breast beam across his lap. He presses alternate treadles, which lowers the heddles to create a shed, or gap, in the warp by lowering alternate single or multiple threads, depending on the pattern to be produced. Then he throws the shuttle from left to right through the shed, presses the treadles again, and throws the shuttle from right to left. The beater is used to press the weft threads tightly together to ensure good quality cloth is produced. The cloth is rolled onto the breast beam as it is completed, and the sled moves gradually towards the loom as the warp is used up.

Once the required length of cloth has been woven, the warp threads are cut. The completed strip of cloth is laid on the ground with other strips which will be sewn together to form the cloth.

Arranging strips to form complete cloth

WEAVING YARNS

Weaving yarns

Apart from the weaver's craftsmanship, the yarn is decisive in determining the quality and durability of the cloth. The Ewe weaving tradition uses a variety of types and qualities of yarn. The quality of the yarn in turn depends partly on the fibre used to spin the yarn.

Originally the only colours of the yarn, and of kente cloth, were black and white. This cloth was called *akpavia*, which means 'crow'. Our forbears then used different plant extracts to develop a wider range of colours, with colours like red, blue, brown and green obtained from plants. The red colour was obtained from dried cam wood; blue was

obtained from the West African indigo plant; brown came from Indian tamarind, and green was derived from boiled leaves of spinach. In modern times, as in the past, coloured threads are unravelled from all sorts of imported material.

Ewe weavers traditionally work with natural fibres – either plant or animal. In the past, yarns were either spun from locally grown cotton or produced by unravelling the threads of imported silk fabrics. However, early in the 20th century, rayon began to replace silk. Today, factory spun cotton, silk and rayon yarns have replaced the locally produced yarn for weaving in Ghana and most other West African countries.

Silk

Silk is the most common animal fibre used in kente weaving. It is produced by the grub of the silk moth, the silk worm, which feeds on mulberry leaves. To make its cocoon, the silk worm extrudes a continuous filament surrounded by a gummy solution, which hardens in the air and cements together the twin threads produced to form the wall of the cocoon. To create silk yarn, the ends of the threads from several cocoons are placed together and twisted simultaneously, into weavers' reeled silk. The silk threads have a natural lustre which gives silk its characteristic smooth, pearly sheen. Silk is traditionally used for laying warp, and is also used for inlaid motifs.

Silk is an expensive fabric, which is not surprising considering that several thousand silk worms are required to produce one kilogram of silk. It is generally reserved for elegant clothing and decorative items.

Silk Cloth

Cotton

Cotton is the end product of the flower of the cotton plant. The cotton plant produces beautiful pink, red or white flowers. After a few days, the petals fall off leaving small round green pods. These are the seedpods of the plant and inside these fluffy fibres grow around the seeds. The pods or bolls gradually become larger and eventually burst, revealing the mass of soft, white, wool-like fibre.

After picking, the fibre has to be ginned. The raw cotton is passed through a machine which separates the seeds from the fibre.

Cotton can then be carded or combed like wool. Cotton yarns need to be scrubbed with starch to make them tough enough for spinning. The yarn is subsequently allowed to dry on the line prior to spinning onto the bobbins. It can also undergo a chemical treatment called mercerisation. Mercerised cotton is stronger and more lustrous and absorbs dye readily.

Since cotton is used for clothes for daily use, the way the cloth protects against varying weather conditions is crucial. The quality

of cotton is normally associated with its absorbency. Cottons which easily absorb moisture without being damaged are the most useful. Cotton fibres are stronger when wet than when dry. Cotton materials are therefore quite safely boiled, scrubbed and wrung.

Today, the cotton yarns supplied to the Ewe weavers are mainly from the Ivory Coast, England and India. These yarns are machine-spun and are dyed with synthetic dyes.

Cotton yarn

Rayon

In the early 20th century artificial fibres began to be produced. One of these was a shining, brittle fibre known as rayon, or artificial silk, although it actually resembled real silk very little except in its lustre.

Rayon fibres are produced by chemical means from natural sources. The raw material of all these fibres is cellulose, either from wood pulp or cotton lint. Rayon has thus some of the features of cotton, but it is not as strong. It takes dye better than cotton and since it is an artificially produced fibre, many different finishes may be introduced, dull or lustrous, fine or coarse and napped or smooth.

Rayon is used in the production of items such as accessories that do not require a lot of wear. It is often combined with other yarns in weaving to improve the lustre of the final product.

MASTER TRAINING

The majority of weavers in the region belong to a lineage of weavers of many generations who learnt the trade the informal way.

Along the West Coast of Africa, the art of weaving with dyed threads spun from cotton and silk was the preserve of men. The Ewe men passed onto succeeding generations, especially their male children, the art of using rich colour combinations in warp laying and weaving a pattern or motif into the cloth they produced from their narrow looms.

Traditionally, an apprentice has to work for months or even years before first sitting in the loom to weave. Initially an apprentice must master spinning. Though spinning is not all that difficult, it takes skill to spin in a speedy manner and to guide the yarn evenly onto the bobbin. After a period of spinning and observing the master weaver, the apprentice begins to weave. He starts weaving small pieces with the warps left on the loom after his master has finished weaving, until one day a warp will be laid especially for his first project. His loom will normally be situated close to the master's loom. It is general practice for all trainees to learn the names and histories of the designs alongside their practical work. They also learn about taboos associated with the trade.

The apprentice continues with his training until one day he becomes a master weaver himself with all the knowledge that entails. Patience and observation are the most important qualities of a skilled weaver.

In addition to this informal way of learning and teaching weaving, a kente-weaving institute has been established at Hatsukope near Denu to train young people who want to learn the art.

The Unique Features of Ewe Kente

The unique features of Ewe kente are determined by its warp and by its weft designs.

A tweed effect may be created by twisting together different coloured yarn to make either the warp or the weft. Many of the warps use yarns of different colours, creating a striped effect. Another popular warp design known as *tsosae* (cut and tied) is achieved by cutting the warp threads at the "nose" of the warp. This creates patterns of thin stripes about four threads wide in certain portions of the cloth, instead of the usual broader stripes. Symbols and motifs woven at intervals into the cloth are another characteristic feature of Ewe kente. These may be representational or more abstract. To produce the most detailed, the weft is passed through the shed by hand rather than with the shuttle.

Inserting the motif by hand through the shed

QUALITY

The quality of kente cloth depends firstly on the weaver's skill. Among other details, it is very important that the cloth is compressed properly during the weaving process to avoid fraying of the weft. The type and strength of the yarns used and their colourfastness also affect the quality. The level of sophistication, and hence the quality, increase with plain weaving, single weaving and double weaving.

In *plain* weaving the main heddle is the only one used. Various threads are used for both warp and weft, but there is a total absence of inlay motifs. Plain weaves are thus easily produced. Examples of plain weaves are *takpepkpe le anloga*, see page 56, and *haliwoe*, see page 59.

Three heddles are normally used in the *single* weave, two main heddles and a pattern heddle. This single weave can result in three types of cloth. In the first, only one thread passes through the loops of the heddle, and silk wefts are often used. An example of plain weave is *suklipkpe* cloth, see page 61.

Spinning yarn together to create the tweed effect (traditional)

Spinning yarn together to create the tweed effect (modern)

The second type involves the use of different coloured thread for the weft, so that different sections of the cloth form small plain or striped blocks. The pattern heddle is used to design the representational motifs in the plain blocks. An example is *toku,* see page 64.

The third type of cloth woven by using three heddles calls for a high degree artistic talent. It is usually made by master weavers. The weaver uses the pattern heddle to insert realistic motifs using traditional ideas and his personal touch. An example is *togodo,* see page 52.

The *double* weave, popularly known in Ewe as *novie*, requires the most skill in the Ewe weaving tradition. Typically four or six heddles are needed for the weaving, two main heddles, and the rest pattern heddles. The pattern heddles allow for a higher ratio of weft to warp threads, causing the weft to completely cover the warp. Because this cloth has more weft threads than the single type of weave it is thicker and heavier. Double weaving is much more concentrated and time consuming since the weaver has to use the pattern heddles in different sequences according to the type of design he or she desires to produce. *Novie* is also known as *akpedo,* see page 50.

USES OF KENTE CLOTH

Kente cloth comes in various forms and sizes depending on how it is going to be used. It has served many purposes in Ewe culture, and now helps to preserve that culture.

Ewe kente was and still is worn as a symbol of pride, a bodily adornment and an object of utility associated with rites of passage and other rituals. It is most frequent seen in use on such occasions as puberty rites, marriage ceremonies, funerals, ordinations of priests and rites for parents with newborn twins. A cloth called *agble*, for instance, is used by a girl who has had her first menstrual period.

Traditionally, the type of cloth worn has reflected a person's financial status. Paramount chiefs, divisional chiefs, elders and other dignitaries wear the best kente cloth at special occasions such as enstoolments and durbars to draw attention to their importance and show how noble and wealthy they are.

Pieces of kente of different designs were used to adorn royal regalia and to decorate drums and other musical instruments.

A cloth with red and white as the dominant colours is often used by fetish priests to cover their fetishes or idols, or, most frequently, as a curtain for the entrance to their shrines. The red colour is said to signify the sacrifices performed to these gods and the white signifies the food served to the gods. Kente cloth may be given to the fetish priest as an offering or to thank the fetish for some service it has rendered.

Kente cloths are often handed down through families, in the same way as stools and valuable items of jewellery. The spirits of the ancestors are said to reside in the old kente cloth, which protects family members from harm. Because of its high value, kente is still sometimes bought as an investment to be passed on to one's children.

There are gender differences in the way the cloth is made. A man's cloth is twenty strips wide, that is, about 80 inches (192 centimetres) and is about 120 inches (288 centimetres) long. A man normally wears one full piece in a configuration similar to the toga in ancient Rome, with his right shoulder and arm uncovered. A woman usually wears two or three pieces of various sizes ranging from four to twelve strips, which corresponds to a width of between 22 and 54 inches (53 to 130 centimetres). She could also wear her cloth as one large piece 72 inches (172 centimetres) wide.

Traditional uses of kente such as those described here can still be found among the Ewe. However, nowadays uses are not as restricted by tradition or by the meanings of the designs as in the past. The cloth is used in a wider variety of ways and many of the designs have been adapted. Kente cloths are worn in the traditional style on many different occasions, for weddings, parties, church services and for formal wear. It can also be used for other items of clothing such as hats, shoes, belts, scarves and ties. Pieces of different lengths can be woven to make bags, table cloths, table runners, place mats, bed covers, wall hangings and picture frames. Strips of kente can be produced with phrases woven into them such as 'Greetings from Ghana'. All these uses keep the tradition of kente weaving alive by bringing the cloth to a wider public, while they show the flexibility of the weavers in adapting their traditions.

Kente is used for various political functions. In the run-up to elections, particularly, one will often see the different party colours mirrored in the kente cloth people are wearing. Supporters of the National Peoples Party (NPP) will typically dress in blue, red and white, whereas the supporters of the other main party, the National Democratic Congress (NDC) will dress in blue, red and yellow.

Kente bedspread

Kente tablecloth

44

FESTIVALS

At the festival

Kente is above all a formal garment worn on special occasions and festivals. In Ghana there are as many festivals as there are ethnic groups. All festivals have political, religious and social significance for the people who celebrate them. In Ewe tradition a festival is a time of public joy and feasting to mark a religious or traditional occasion. It is usually heralded by drumming, singing and dancing. Festivals offer opportunities for visits home, mourning for those who died during the year and opportunities to thank God and the spirits for care and protection during the past year. The festivals may mark the beginning of a traditional year or celebrate the beginning of a new agricultural year. They may celebrate the harvesting of staple foods such as yam or rice.

Nearly all festivals involve rites of purification by the chiefs and the traditional priests, while the people renew their loyalty to their chiefs by paying homage to them. Festivals facilitate settlement of family disputes and give young people the opportunity to get to know each other and contract marriages. They contribute to the development of the area in general.

The two festivals most associated with Ewe kente are *Hogbetsotso* and *Agbamevoza*.

Hogbetsotso is a popular annual festival celebrated by the Anlo community to commemorate the sufferings of their forebears during the era of King Agorkoli. It

occurs during the first week of November. For the Ewe people the *Hogbetsotso* festival is the most important festival during which kente is worn.

The Agotime Kpetoe people have instituted a festival, *Agbamevoza*, referred to by some people as the Kente Festival, to commemorate the past and present achievements of the weavers in the area. Here tourists, local people and students of kente can see a wide variety of cloth. The first Kente Festival was celebrated in 1966.

Chiefs wearing kente cloth at the Hogbetsotso festival

The festival is full of colour and activity. Old pieces of kente are on display, and many examples of traditional weaving are for sale. Present day weavers from Agotime and neighbouring districts display their talents as they work on different types of kente.

Many local visitors dress in their traditional kente cloths, including the chiefs and other dignitaries who witness the proceedings. Dancers perform the *agbadza*, a traditional Ewe dance, to the sound of drumming.

48

Meanings of Ewe Kente

Kente is used not only for its beauty but also for its symbolic significance. As with other traditional textiles, the different designs of Ewe kente cloths have different meanings.

All the motifs woven into kente cloth can be grouped into three types. The first are the geometric motifs. A pattern is created with different geometric forms, each in a different colour, with the pattern repeated throughout the strip of cloth. Next there are simple representational shapes, the older form of representational motif. Lastly, there are more modern, more realistic representational symbols. When they are finished, the strips of cloth are combined according to the colours of the warp and to the arrangement of the motifs in order to create the best effect.

The following are some of the designs most often found in Ewe kente, with explanations of their meanings. They are arranged in order from the oldest known type of weaving to the most modern.

Akpedo

AKPEDO (NOVIE)

Akpedo means 'Together' or 'Unity'. This cloth is one of the oldest known types. Different coloured threads are plied together for the weft and in some cases for the warp. It is woven using four heddles. It expresses the popular Ewe saying that 'two heads are better than one', or, one tree does not make a forest. It thus expresses the social value of collectively sharing the wealth and knowledge created by individual members of the society, who are bound together by their close relationship. It symbolises peace and unity.

Fiawoyome

FIAWOYOME

Fiawoyome literally means 'The chief's retinue'. The name stems from the saying 'ma tae manor fiawoyome', which means 'let me wear it and follow the chiefs!' Normally our chiefs appear in white cloths during special functions. The cloth refers to the social desire for our chiefs to protect us in order to ensure the survival and continuity of the society as a whole. In the olden days, such cloths were normally worn by the chief's retinue during special occasions and distinguished them from other personalities in the chief's palace. The design symbolises social security, accomplishment, survival and continuity of the society.

Togodo/Adanuvo

TOGODO/ADANUVO

The cunning nature of the Ewe weavers comes alive with the *togodo* or *adanuvo* cloth. More realistic symbols can be seen in this cloth (see Table 2). The 24 small squares surrounding each symbol in the cloth clearly refer to the 24 days it took our forefathers to elude King Agorkoli at Notsie in Togo and settle on the soil of Ketu in the Volta Region before they continued their migration to other parts of the region. The numerous figurative symbols tell us that this world is a very big place but through vigilance and prudence it is possible to maintain a balance in life.

In the past, kings and people of high status and wealth wore *togodo* or *adanuvo* cloth. It symbolises superior craftsmanship, royalty and creativity.

Meaning of symbols woven into togodo/adanuvo and other cloths

Symbol	Meaning
Armpit talking drum	praise, adoration, oral history, translation and poetic skill
Bird	merry making
Butterfly	punctuality
Bicycle pedal	progress
Chameleon	patience
Comb	grooming and enhancement of our physical appearance
Cowry	wealth, luck and fertility
Crocodiles joined at the stomach	a proverb which says people with a common interest should not quarrel with each other
Crocodile skin	protection
Dove	neatness and peace
Elephant	kingship
Fence	a village
Fishing net	bringing people together
Hand	peace
Knife	a practical symbol: symbol of efficiency, productivity and sharpness
Ladder	a tool for achieving greater heights
Leaf	shelter
Necklace	just an ornament
Parrot	a pet noted for its tail
Pineapple	Friendship. The pineapple is difficult to peel, which symbolises a strong friendship, whereas a banana is easy to peel and thus symbolises weakness.
Scorpion	bitterness
Stool	money, or winning the war
Umbrella	chieftainship

Babadu

BABADU

Babadu is another of the oldest types of weaving. It literally means 'termites have eaten'. The appearance of this particular cloth shows the way termites normally devour items into the smallest particles. It therefore tells us that death is inevitable.

Ehianega

EHIANEGA

Ehianega literally means 'it calls for money'. The popular Ewe proverb from which this cloth takes its title underlines that wealth promotes manliness. The traditional use of the word 'manliness' makes reference to the wisdom, creativity, action-orientation and power that an individual may possess. Before a person can maintain personal integrity and high ethical standards, they need to be supported by wealth. Success can only be achieved in the end by using our knowledge and possessions fruitfully. This cloth carries the notion that a successful undertaking always calls for money.

Kpevi

KPEVI

Kpevi literally means 'double stones'. This cloth is woven using two different warps at the same time on the same loom. The warp bundles are unwound to a distance, tied to two stones, and normally placed on sleds. Two different sheds are created instead of the usual one. This cloth derived its name from the two stones used. It represents the two systems of authority in our communities, which ensure cohesion and the balance of power. These two authorities are the head of the family and our local chiefs. It symbolises authority, lawfulness and social cohesion.

Woha Tsi Nata

WOHA TSI NATA

Woha Tsi Nata literally means 'you too can make it and wear it'. The design is a reply from the wearer or the weaver. This cloth became a favourite of Ewe students of the then Achimota College in Accra together with imported 'Achimota Sandals'. The cloth is also called 'Achimota' to this day. It symbolises contentment and attractiveness.

Takpekpe Le Anloga

TAKPEKPE LE ANLOGA

Takpekpe Le Anloga means 'There is a congress at Anloga'. This cloth is in remembrance of the conference held by the paramount chief of Anloga, *Torgbui Sri*. The conference was attended by kings, chiefs and sub chiefs after it was discovered that the stool had been left behind at Notsie. It is believed that on the day of the congress all attendants were in a common uniform, later known as *takpekpe le anloga*. Therefore our forbears saw the cloth as the symbol of office-holders.

GALE ANYAKO

Gale Anyako literally means 'There is money at Anyako'. Anyako is a village on the peninsular of the Keta lagoon, in the south of the Volta Region. This cloth was designed to express recognition of salt as a wealth generating commodity and a preservative, without which food would be tasteless and even 'huge amounts of elephant meat would decay after a few days'. Thus, our forefathers recognised that they are living in one of the richest areas in Ghana.

Gale Anyako

SOGEY

Sogey has two meanings. The word *sogey* literally means lightening; it is a relic or spiritual object and takes the image of thunder. The second meaning is based on a legend, which says that *Adele Dzavoe*, a powerful hunter, shot dead an elephant. When he cut open the carcass and carved the meat into pieces he discovered a pearl of great price inside the elephant's stomach. This jewel became the mysterious and legendary *Rainstone* in early Anlo history. The cloth tells us about this jewel, forever concealed; when it is shared, the pleasure it gives becomes deeper and more powerful. The cloth thus symbolises fertility and potency.

Sogey

Klogo

KLOGO

Klogo means 'the shell of a tortoise'. The cloth carries the shell throughout its motifs. It comes in a variety of colours but since that symbol of protection is kept throughout the background, different colours have little significance. The cloth is designed and named to commemorate our forefathers who fought and ran away from King Agorkoli. It remembers that historic event and honours the soul of our grandfathers for their bravery. The cloth thus symbolises protection, heroic deeds and social vigilance.

LOKPO

Lokpo literally means the 'back of the crocodile'. A popular saying goes, 'Crocodiles do not drown in a river no matter how deep the river is'. Our forefathers believed that no matter how difficult a situation was, they could always keep their heads above water. It symbolises endurance, enlightenment and confidence.

Lokpo

HALIWOE

Hali, which means 'sprouted maize', is used to prepare a local drink popularly known as *ekudeme*. When the maize is specially treated it germinates and sprouts, and from this process comes the notion of *haliwoe*. *Haliwoe* is 'lots of sprouted maize' since 'Woe' in Ewe indicates plural. The pattern on the cloth looks like the sprouted maize, hence its name. It symbolises unity, strength, growth and productivity.

Hali woe

Afiadekemefao

AFIADEKEMEFAO

Afiadekemefao literally means 'there is trouble everywhere'. It tells us that success and failure are inevitable in this world since external circumstances play a major role in our lives. Many people know what they would like to do with their lives, but they don't know how to get there. The best way to prepare for the future is to live each day in such a way that there will be no reasons for regret. The symbolism in the *afiadekemefao* reminds us of things we can control, such as our attitudes, the friends we choose and our willingness to study and work to the best of our ability and potential. This will all help guide the course of our future.

Trogbo

TROGBO

Trogbo literally means 'turn over'. This design is in commemoration of the mass exodus from the Kingdom of Notsie. It was believed that during the escape from Notsie our forbears turned and walked backwards to avoid detection. The cloth depicts each group or convoy of the escape. It symbolises intelligence, bravery and guidance.

Suklikpe

SUKLIKPE

Suklikpe literally means 'cube of sugar'. It symbolises mutual love. Our forefathers believed that one great sin of humanity is ungratefulness, and this cloth symbolises sincerity, appreciation and acknowledgement. It is woven with different colour backgrounds.

Wargagba

WARGAGBA

Wargagba cloth has different meanings depending on whether it is woven on a white or black background. When it is woven on a white background, it represents high achievement. It therefore symbolises perseverance and advancement. When woven on a black background, it is associated with human mortality, which affects us all.

ATIDEKA

Atideka literally means 'one tree'. This cloth was named after the one palm-nut tree, planted on a rock at Ado by the soothsayer Yemaja, who taught the inhabitants of his village how to foretell future events. From this single seed, sixteen palm trees instantly grew up. The cloth thus symbolises survival, chieftainship and supremacy.

Atideka

GBADEGBENYO

Gbadegbenyo means 'The happy days are gone'. It was believed that the peace and stability our forefathers enjoyed was irreparably destroyed through the long years of the European trans-Atlantic slave trade, which brought bitterness and divided villages and people. This cloth therefore symbolises the unity, peace and self-sufficiency which our forebears once enjoyed as one people with a common ancestry and destiny.

Gbadegbenyo

Toku

TOKU

Toku literally means 'The big animal is dead'. The Ewe name for the buffalo is 'eto', whereas 'ku' means dead. The havoc the buffalo causes when hunters try to kill it and the apparent peace the community enjoys when it dies is thus expressed by the name of the cloth, *toku*. *Toku* was therefore woven and worn to commemorate the demise of wicked kings. It symbolises liberation, growth and self-confidence.

Sasa

SASA

Sasa is a cloth made up of strips of many different designs sewn together and symbolises acceptance or unity among a clan or a group of people.

Lorlorwuho

LORLORWUHO

Lorlorwuho literally means 'Love is precious'. In the Ewe tradition, this cloth is one of the most valuable assets during marriage ceremonies. It is always included in the woman's bride price as a sign of respect and love for the in-laws of the bridegroom. It symbolises love, humility and perfection.

Doklidokpo

DOKLIDOKPO

Doklidokpo literally means 'the three united powers'. It commemorates the indomitable fighting spirit of our forefathers through the inspiration of the three united stools namely, the ancestral stool of *destiny*, the stool of *labour* and the stool of *fortune and wealth*. Thus the cloth symbolises power, wealth and bravery.

Amegbor

AMEGBOR

Amegbor literally means 'come back'. This is a reference to the permanent Ewe kingdom once established at Notsie. The kingdom was acclaimed as the ancestral home of all Ewes after they arrived from Hogbe. The cloth thus symbolises sovereignty and dignity.

Nlornlordzanyi

NLORNLORDZANYI

Nlornlordzanyi literally means 'The writing has come to sit'. The cloth expresses the system of governance where the traditional council liaises with the offices of the higher authorities to make by-laws and to regulate the activities of people living in the various communities. It symbolises authority, development and patriotism.

THE NATIONAL FLAG

Very often cloths one can see in the Ghanaian market are in the four colours of our national flag – red, yellow, green and black. The red colour always reminds us of the struggle for independence. During the independence struggle, many people lost their lives, so red stands for the blood of those who died in the struggle. The yellow colour symbolises the gold and the other valuable minerals found in Ghana. The green colour refers to the rich forest and fertile farmland which bless our country. Finally, the black colour of the star celebrates the fact that Ghana was the first Sub-Saharan African country to get independence and that all black African states will be free one day.

Afterword: Keeping Kente Weaving Alive

Women wearing kente cloth

Today it is common to hear weavers complaining about the lack of a ready market for authentic kente cloth. Some react hastily by producing low quality for the local market only.

There is another opportunity, however. This is further development of the artistic quality of kente weaving with all its history and traditions, using the proven skills of the kente weavers. Kente weaving possesses a range of qualities in high demand. It is hand-woven by skilled craftspeople. It is an authentic craft – each and every piece of cloth is unique. It is part of our African heritage.

All kente weavers, Ashanti or Ewe, should join hands and promote quality kente weaving and its accessories all over the world – through personal contacts, professional networks and the Internet.

Kente is a textile of royalty, with a long history in West Africa. Kente weavers should produce of their best in order to maintain and develop further this authentic cultural gift for the world's pleasure.

December 2003,
Ahiagble Bob Dennis

FURTHER READING

KETEKU III, Nene Nuer (2001). *The Art, Craft and Philosophy of Kente in Ghana.* Paper by the Konor (paramount Chief) of the Agotime Kpetoe Traditional Area.

KRAAMER, Malika (2002). *Ghanaian Kente: Not Every Cloth has a Border.* Paper presented at the International Symposium on Performing Culture. The Politics and Aesthetics of Cultural Expression in Contemporary Ghana, 13-14 June 2002. Amsterdam (Royal Institute of the Tropics).

MEZEL, Birgit (1990*). Textiles in Trade in West Africa.* Paper Presented at the Textile Society of America: Symposium, Textiles in Trade. Washington D.C. September 1990.

SAFO-KANTANKA, O.B. and Oti Awere, J. (1998). 'Facts about the Origin, Discovery and Evolution of Kente' in *Bonwire Kente festival: 300 years of Kente Evolution, 1697-1997.* Festival Programme.

ADLER, Peter and Nicolas Barnard (1992). *African Majesty: Textile Art of the Ashanti and Ewe.* Thames and Hudson, London.

DENDEL, Esther W. (1974). *African Fabric Crafts: Sources of African Design and Technique.* New York: Taplinger.

GILROY, Peggy S. (1987). 'Asante and Ewe Textile Traditions' in *Patterns of Life: West African Strip-Weaving Traditions,* pp. 33-42. Washington, DC: Smithsonian Institution.

OFORI-ANSA (1993). *Kente: More than a Cloth: The History and Symbolism of Ghana's Asante Kente Cloth.* Hyattsville, MD: Sankofa.

PICTION, John (1979). *African Textiles. Looms, Weaving and Design.* London: British Museum Publications.